JUNGLE JACK HANNA'S
SAFARI
ADVENTURE

by Jack Hanna and Rick A. Prebeg • Photographs by Rick A. Prebeg

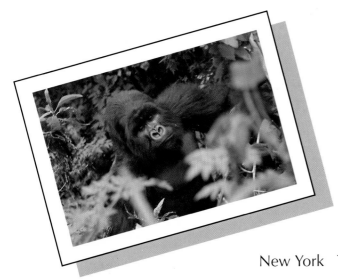

Cartwheel
·B·O·O·K·S·®

SCHOLASTIC INC.
New York Toronto London Auckland Sydney

Acknowledgments

Special thanks to Diane Muldrow, editor, and Edie Weinberg, art director, for their great work at sifting through pages and pages of manuscript and thousands of slides, so that they could translate the beauty and fantasy of an African safari into the written word; and Sally South, my extremely competent Administrative Assistant, for keeping things together while I'm out on safari far, far away.

—J.H.

Special thanks to Jungle Jack for so many adventures over the years; Eddy and Jeannine Farmer and Bob Mauck for all their support and for their contributions to this book; Harry Peachey and Peter Nyamenya for their advice on scientific accuracy; my wife Carole Prebeg, for her passion for reading and her encouragement in writing this book; and my brother Frank and sister Dana for always supporting my desire to travel to adventure-filled parts of the world.

—R.P.

Special thanks to J.R. Johnson and Kathryn Deyerle of VideoTours/Animal Adventures, for initiating the filming project that led to this book; Nancy Rose; Vickie Moon Spiegel; Harold Gordon and his excellent staff at Park East Tours for making this book possible and for always handling our safari arrangements perfectly (we've never had a boat overturned by hippos, and have never been stranded anywhere); Marcia, Stacy, Janet, Lauren, and Sondra for all their hard work; all our professional guides, trackers, and drivers for always finding Africa's wildlife and for teaching us the customs of the land; the people of East and central Africa for their friendliness and cooperation; and Columbus Zoo for its support of nature travel and conservation in all parts of the world.

—J.H.
—R.P.

ISBN 0-590-67322-X

Text copyright © 1996 by Jack Hanna.
Photographs copyright © 1996 by Rick A. Prebeg/World Class Images.
Photograph page 8 © and courtesy Jeff Ruff.
All rights reserved. Published by Scholastic Inc.
CARTWHEEL BOOKS and the CARTWHEEL BOOKS logo are registered trademarks of Scholastic Inc.

Library of Congress Cataloging-in-Publication Data
Hanna, Jack, 1947–
Jungle Jack Hanna's safari adventure / by Jack Hanna and Rick A. Prebeg ; photographs by Rick A. Prebeg.
p. cm.
Summary: A personal account of zoo director and television show host Jack Hanna's safari through East Africa.
ISBN 0-590-67322-X
1. Zoology — Africa, East — Juvenile literature. 2. Safaris — Africa, East — Juvenile literature. 3. Wildlife photography — Africa, East — Juvenile literature. 4. Hanna, Jack, 1947 — Journeys — Africa, East — Juvenile literature. [1. Safaris — Africa, East. 2. Zoology — Africa, East. 3. Photography of animals — Africa, East.] I. Prebeg, Rick A. II. Title.
QL337.E25H36 1996
591.9676 — dc20

95-43861
CIP
AC

12 11 10 9 8 7 6 5 4 3 2 1 6 7 8 9/9 0 1/0

Printed in Singapore

First Scholastic printing, October 1996

In memory of my parents,
Hoss and Carrie Hanna,
and our African safari in 1985
— J.H.

To my parents,
Frank and Betty Prebeg,
who have always
encouraged my love of
wildlife and adventure
— R.P.

INTRODUCTION

Do you know what a safari is? It used to be a hunting trip to Africa, but these days it's a journey to see and photograph all the fascinating animals that live there.

When I was a boy living on a farm, I dreamed about going on safari. I wondered what it would be like to see elephants and lions, giraffes and hippopotamuses living in the wild, and to hear the nighttime cries of animals around my camp.

When I grew up and became a zoo director, I finally had my chance! I wanted to produce a series of television shows on the animals of Africa, so I organized a film crew of eight people. Finally the day came when we boarded a jumbo jet that flew us to Nairobi, Kenya. We spent a month in Africa filming many, many animals, and it was a wonderful adventure for all of us!

As you read this book, you'll feel like you're on safari, too!

Jack Hanna

Lake Turkana

UGANDA
KENYA

Kampala
Mt. Kenya

Lake Victoria
Nairobi

Bwindi Park
Masai Mara Reserve
Amboseli National Park

Africa

The continent of Africa, shown at left, is made up of about 50 countries. Enlarged are the two countries that we visited on our safari — Kenya and Uganda. MAP BY VICKIE MOON SPIEGEL

THE SAFARI BEGINS

We left Nairobi and drove for six hours on bumpy, dusty roads until we reached the savanna. A savanna is an enormous grassland dotted with trees. Sometimes we saw rivers or streams. I was glad to finally arrive at our lodge in the Masai Mara Reserve.

Game preserves and national parks are the best places to see animals in Africa. Animals that stay within their borders are protected by park rangers. These animals are used to seeing people and film crews, so they aren't afraid. For this reason, it's easier to film the animals.

Courtesy Jeff Ruff

Our wonderful guide, Ahmed.

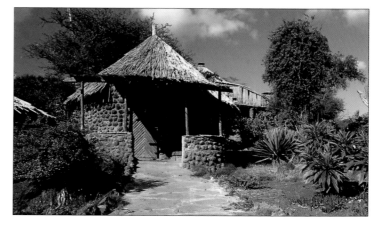

Our lodgings were made of wood and bamboo with thatched grass roofs.

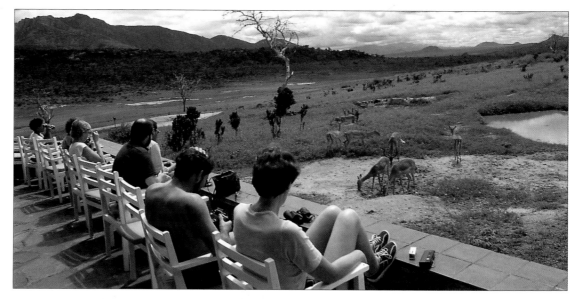

Behind the lodge, impala often came to drink water in the afternoons.

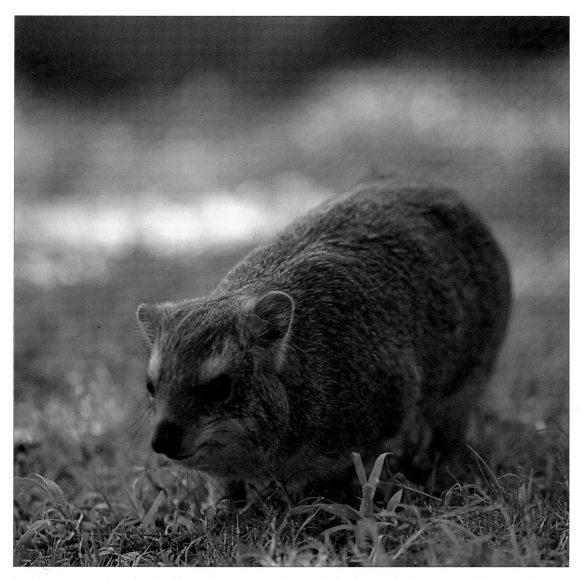

After dinner that night, we got our cameras ready for the next day. We would be waking up at five a.m. We wanted to film the animals early in the morning, when the air is cool and the animals are more active.

Right after breakfast the next morning, we climbed into our safari minibuses and headed out over more very bumpy roads! We were going on a "game drive" through the bush country.

This hyrax and her family lived right by our lodge. Would you believe that this small furry creature is more closely related to the elephant than to the groundhog?

"What animals will we see today?" I asked our guide, Ahmed.

"Going on a game drive," said Ahmed, "is like going fishing — you never know what you're going to get!"

A few minutes later, Ahmed pointed to a faraway tree and said, "Look there! Baboons!"

How could Ahmed see baboons, I wondered, when I could barely see the tree? I knew then that Ahmed would be a great guide!

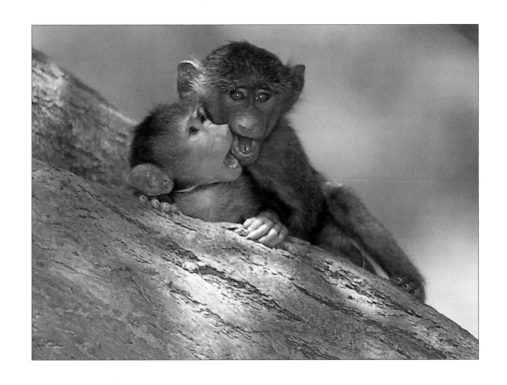

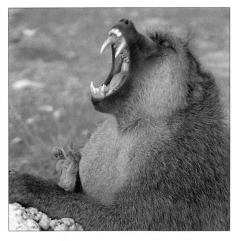

When this baboon yawned, we saw how sharp its teeth were.

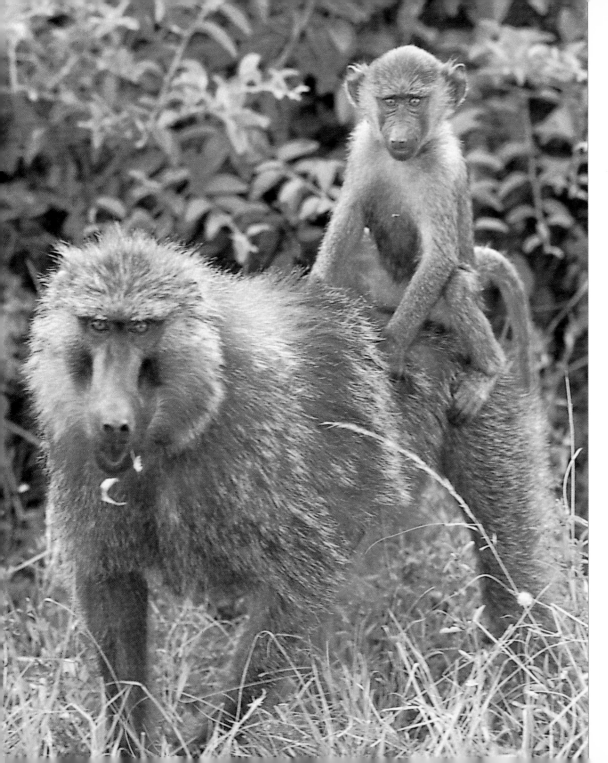

We approached the tree quietly so we wouldn't scare the baboons away. What an amazing sight it was! We filmed them going through a typical "baboon day."

Making loud screeching sounds, many of them cracked open the tree's long pods in search of the seeds inside. Some combed through each other's fur and picked out insects. This is called "grooming," and it was funny to watch! But even funnier were the little baboons. They seemed to be playing "tag," chasing each other up and down the tree!

Baby baboons stay with their mothers all day, riding around on their backs.

After leaving the baboons, we came upon a water hole, which is a depression in the ground that fills up with rainwater. A water hole is an interesting place, because you can see many types of animals there.

It wasn't long before a large herd of Cape buffalo lumbered toward the cool water.

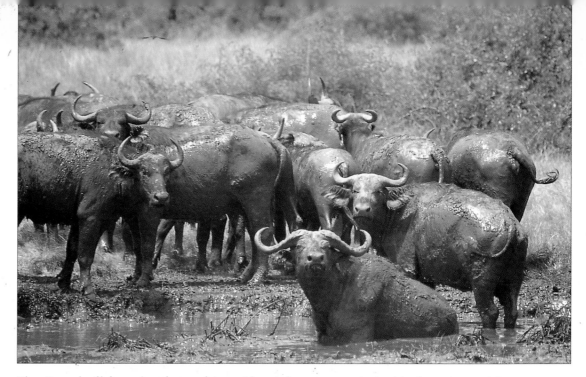

The Cape buffalo cover themselves with mud to protect their skin from insect bites.

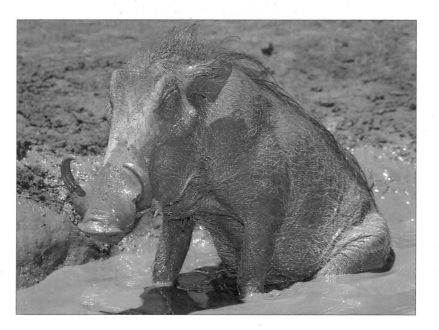

This warthog seemed to love its mud bath.

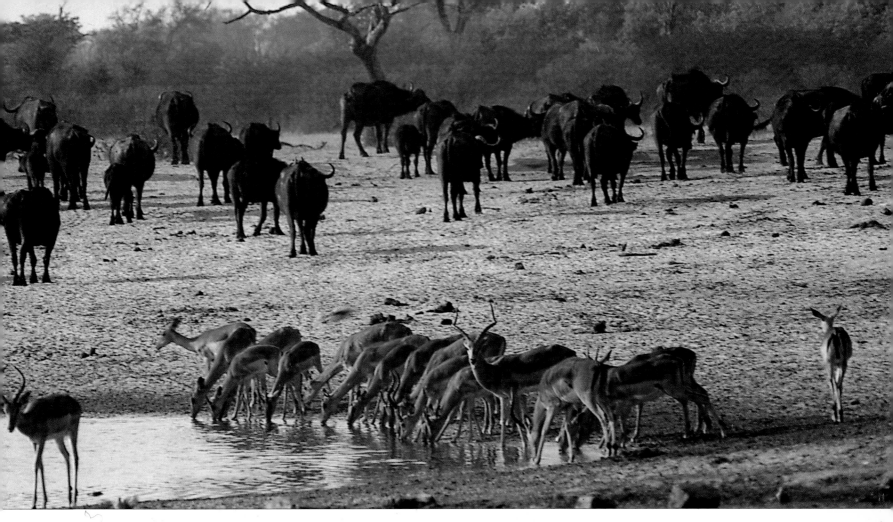

The impala finally got their turn at the water hole.

Nearby, some impala watched and waited. Cape buffalo are much bigger than impala and can be mean tempered.

After drinking for about an hour, the buffalo turned and disappeared into the grassland. The impala finally had their chance, and quickly moved in!

"You see," said Ahmed, "it pays to be patient and wait your turn!"

13

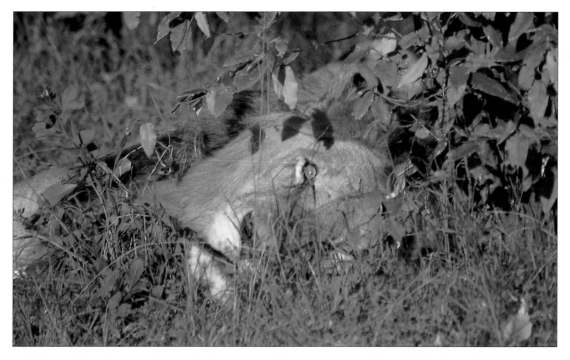

Male lions like this one have thick manes of hair to protect their necks during fights with other males.

As the day grew hotter, we hoped to see a lion or two, since it was now "naptime." Lions rest a lot during the day to save their energy for hunting.

Sure enough, Ahmed's sharp eyes spotted a lion sprawled under a bush. The lion soon knew we were filming him, but he didn't seem to mind!

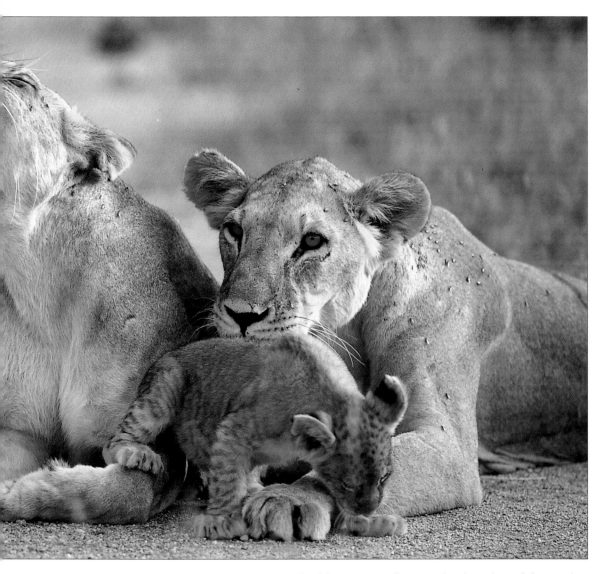

I looked through my binoculars. "Look! There's another one!" I said.

I felt lucky to see a group of lions, which is called a "pride." Each pride has one male who watches over the females and their cubs. But it's the females who do most of the hunting.

Lion cubs like to stay close to the females of the pride.

Those lions acted a lot like my cats at home! I could have watched them all day, but there was still so much to see.

We drove along and enjoyed the beautiful African landscape . . . snowcapped mountains, rolling hills, golden savannas, and unusual flat-topped trees called "acacias."

I loved driving through the savanna, because it is home to so many animals.

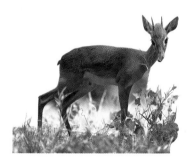

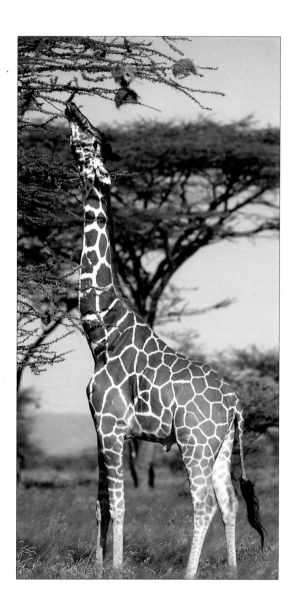

A giraffe nibbles on tender thorns of an acacia tree. A giraffe can be three times as tall as a person, so it's easy to eat from the treetops . . .

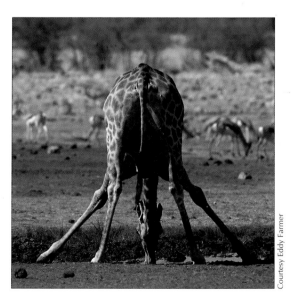

but drinking water is a little more difficult.

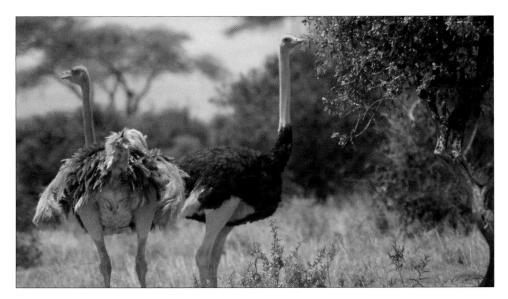

Ostriches can't fly, but they can run up to 40 miles an hour.

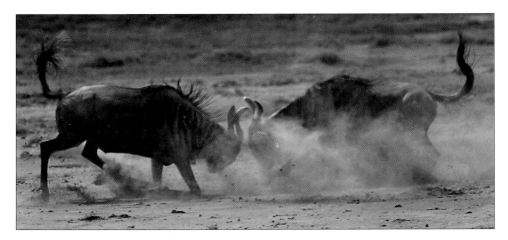

Wildebeests sometimes fight each other to protect their territory.

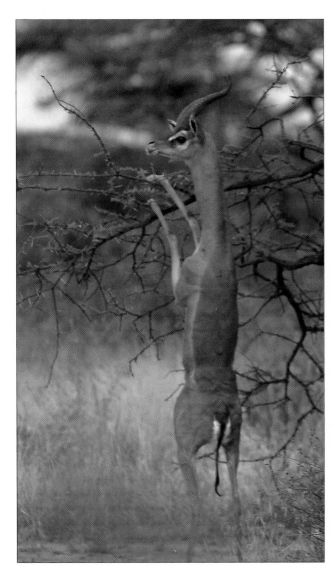

The gerenuk is able to stand up on its hind legs to reach food other animals can't.

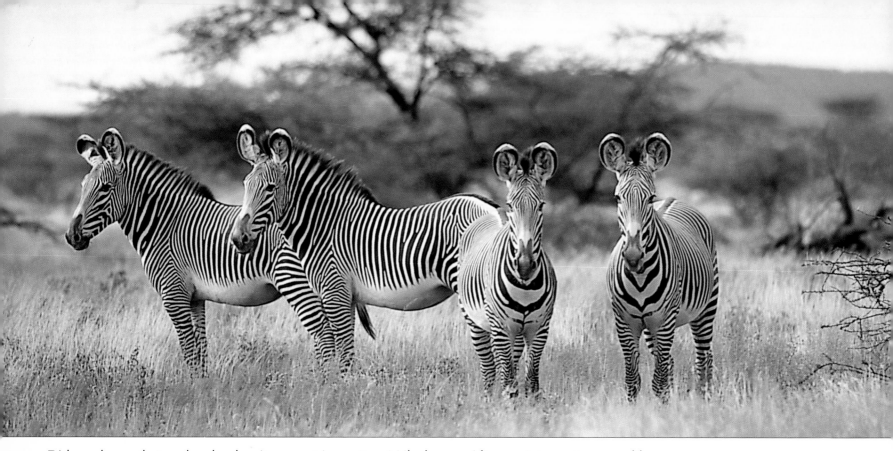

Did you know that each zebra has its own stripe pattern? Like humans' fingerprints, no two are alike.

"Kwa-ha-ha! Kwa-ha-ha! Kwa-ha-ha!"

"Hey, what's that funny sound?" I asked Ahmed.

"Haven't you ever heard a zebra before?" he replied.

A short drive took us to a herd of Grevy's zebras grazing on the grass. They looked like horses with donkey-like ears and black-and-white stripes. The stripes act as camouflage within the herd. All those stripes blend together, making it difficult for a hungry lion to single out a zebra!

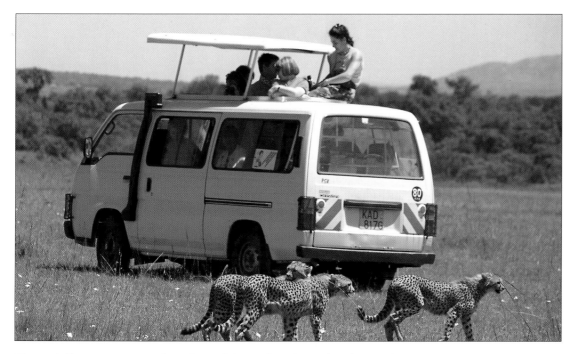

Our minibuses were perfect for safely seeing the animals up close.

We had to be back at the lodge before dark, so we climbed back into our minibuses.

I always enjoyed the evenings in Africa. Around the campfire, everyone would talk about the animals we had seen and the spectacular sights along the way. The film crew would prepare their cameras for the next day's filming. I could hear the sounds of hyenas "laughing" and lions roaring in the distance. It was exciting and a little bit scary!

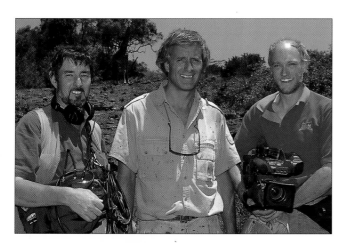

My film crew did a great job. Dan Devaney *(left)* was in charge of the microphones. Roger Grange *(right)* was the cameraman.

One morning during a game drive, we met a young boy who was tending some goats. Ahmed was able to speak his language. He said that the boy was one of the Masai people who lived in a nearby village.

"Could he take us there?" I asked Ahmed.

The boy said he could not leave the goats, but he pointed us in the right direction, and we headed toward the Masai village.

At the village, we met Olekuraru, a Masai man who spoke English quite well. He told us about the Masai people.

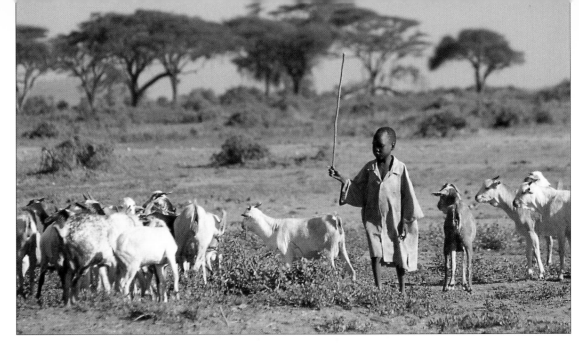

This Masai boy tended his family's goats and cattle daily, from early morning until dark.

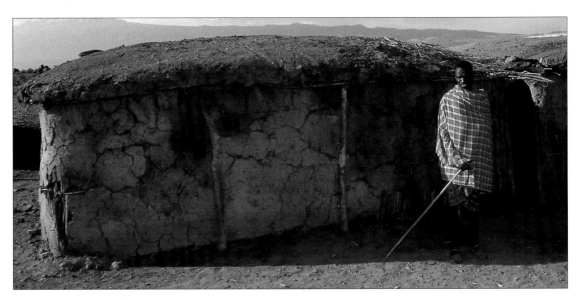

Olekuraru in front of his family's home, which is made of mud, dung, and sticks.

"Everyone here has a job," he said. "The young girls milk the goats. The boys tend the cattle. The men make sure that everything in the village runs smoothly. The women cook, clean, gather and chop the firewood, and take care of the family. The older men, called 'elders,' are highly respected and their job is to settle any disputes that may occur in the village."

The more livestock a Masai family owns, the richer it is.

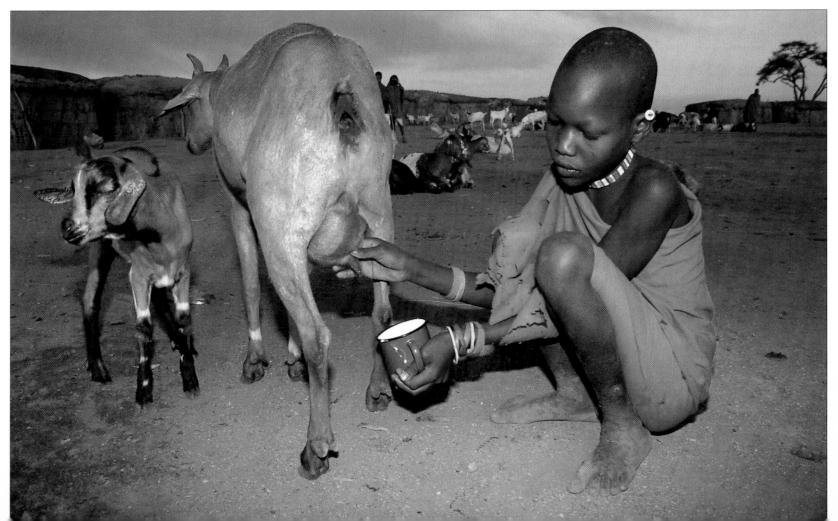

Olekuraru went on to say that the Masai people would be happy to perform a ceremonial dance for us. He added, "You see that the young men and girls are dressed quite well, and their singing is equally as good!"

We enjoyed the ceremony very much.

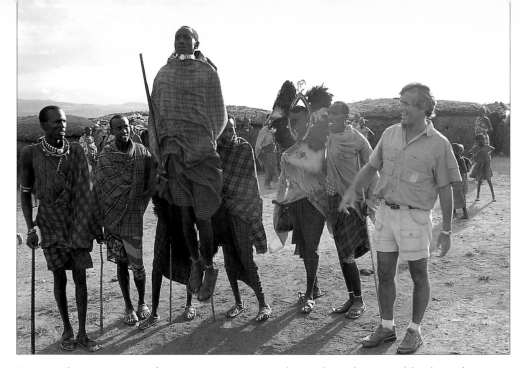

During the ceremony, the Masai men sang, danced, and jumped high in the air. I tried to copy their dance — but I wasn't very good! Everyone just laughed!

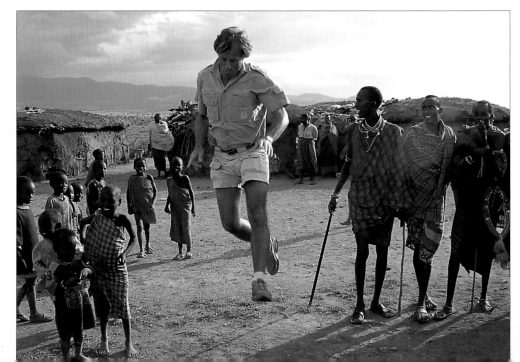

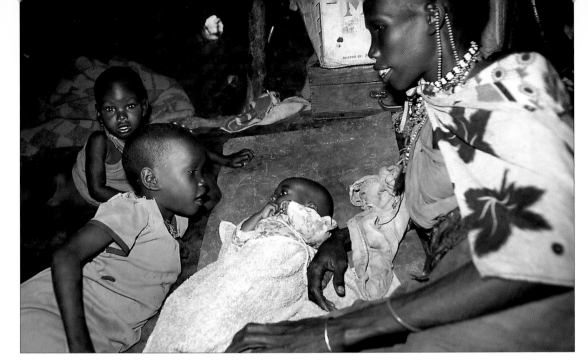

This busy Masai mother invited me into her home to meet her children.

All too soon, it began to get dark, and the young boys were bringing the cattle and goats home for the night. We said, "*Kwaheri*," which means good-bye in Swahili. I hoped that I would be able to come back to visit the friendly Masai people again one day.

We drove back to camp under a sunset of brilliant orange and gold. It was a perfect ending to a day I'll never forget.

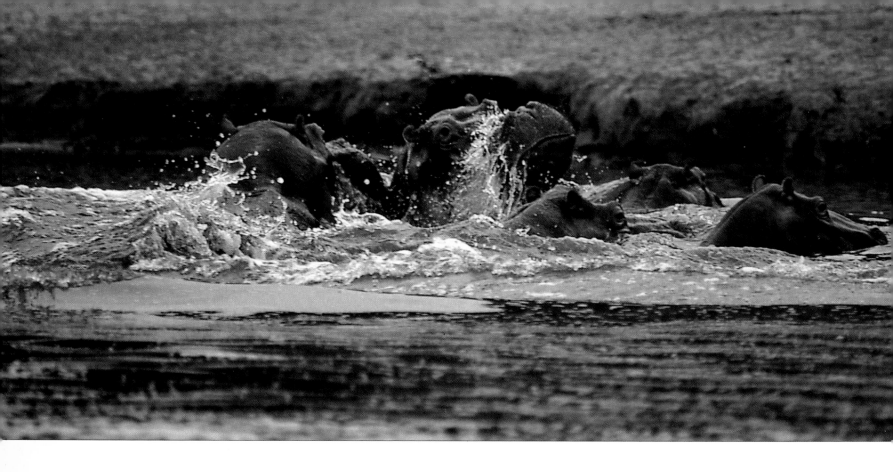

One afternoon we got in our minibuses and drove to a riverbank.

We walked very quietly to the river. Suddenly, I heard loud honking sounds that almost made me jump out of my skin!

"What's that?" I shouted.

It was twenty huge hippopotamuses cooling off in the river! Even though a hippo can weigh more than a car, it can run very fast, so we filmed from a safe distance.

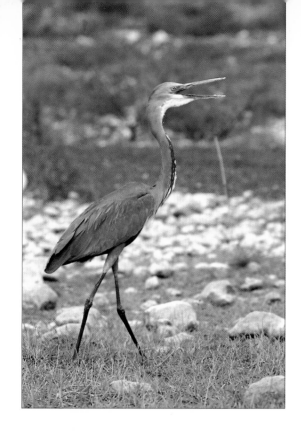

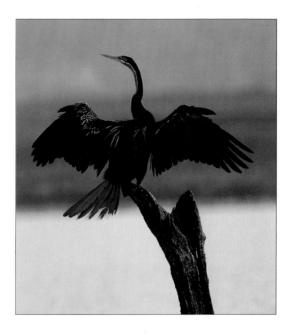

We saw many birds around the water — some picking insects right off the hippos' skin, some looking for fish.

Left: A Goliath heron walks near the shore searching for a meal.

Right: The anhinga catches a fish by swooping down right into the water.

Below: We had to be careful while walking near the river — crocodiles were everywhere.

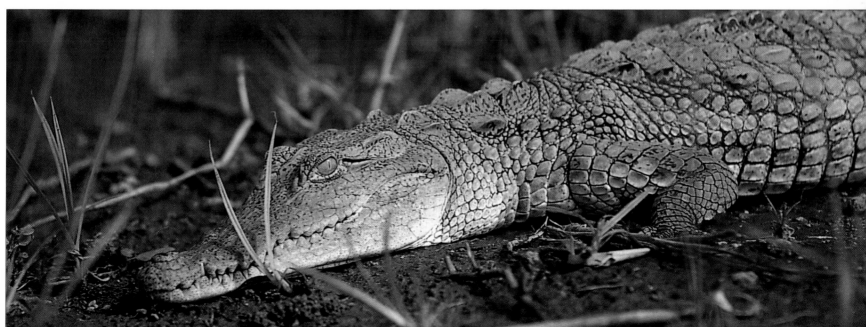

Early one evening we saw a cheetah make a kill.

The cheetah is the fastest-running animal in the world. It can run as fast as a car on a superhighway — about 70 miles an hour!

You would think that a cheetah would have no problem catching food, but its kind of speed is only good for short sprints, and then the cheetah tires quickly.

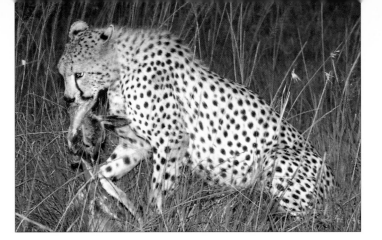

This cheetah caught a young gazelle. He was too busy enjoying his dinner to mind us being nearby.

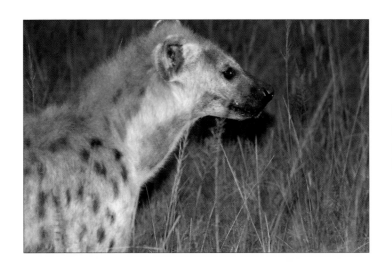

Suddenly a hungry hyena appeared. Hyenas often steal food instead of hunting for their own.

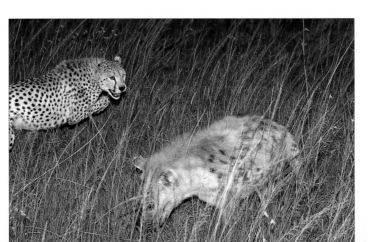

The cheetah hissed and barked — but a cheetah is no match for a fierce hyena.

When the hyena finished eating, a jackal came and picked at the bones. No food is wasted on the savanna.

The cheetah had only an appetizer that evening. He would have to wait until he regained his energy to hunt again.

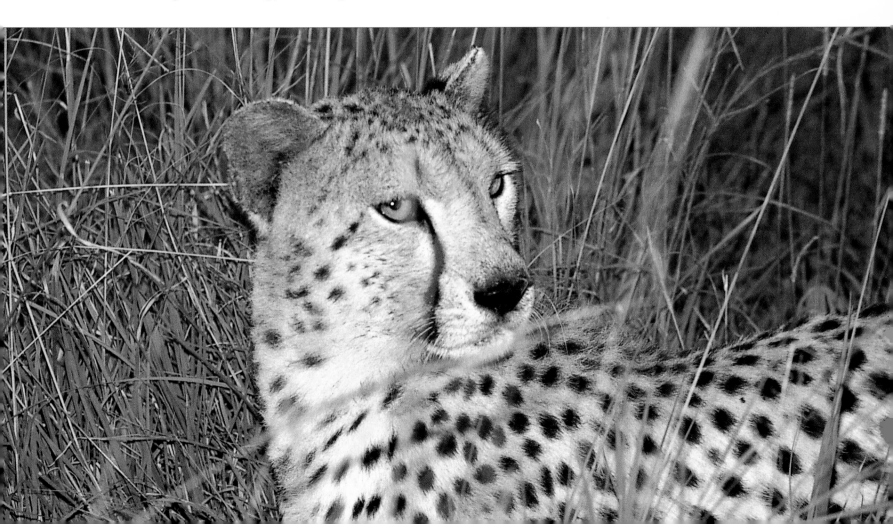

We returned to the water hole one day to find a large herd of elephants wading with their trunks outstretched.

Do you know how an elephant drinks? It sucks gallons and gallons of water into its trunk, and then points the trunk into its mouth and sprays all the water in!

An elephant's trunk is powerful. It is used like a hand to gather leaves, branches, and tree bark for a meal. A pile of grass and leaves that an adult elephant eats in a day can weigh as much as a large person!

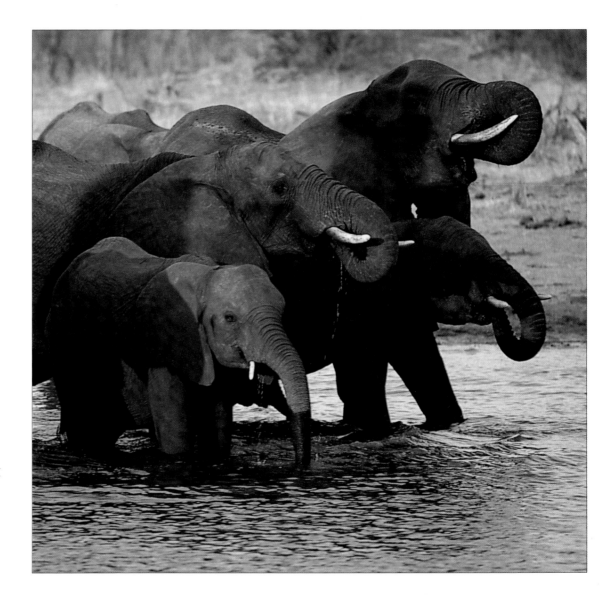

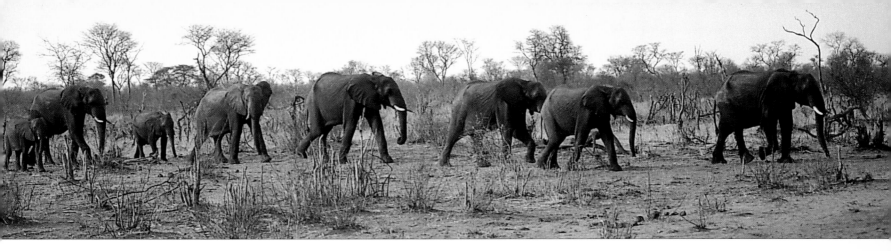

The elephant is known as a pachyderm, which means "thick-skinned." Other pachyderms are rhinoceroses, hippopotamuses, and tapirs.

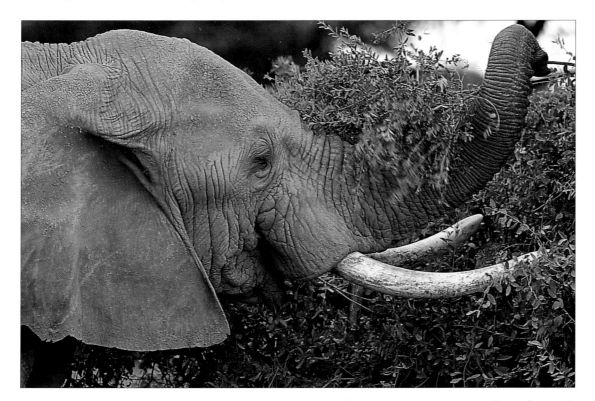

The elephant uses its ivory tusks as digging tools. Sadly, many elephants have been hunted for their tusks, which have been carved into figurines and jewelry. The selling and buying of ivory is now against the law in many countries.

Driving away from the elephants, we noticed another pachyderm far away.

"It's a rhinoceros!" I said. "Let's go!"

We drove slowly toward the rhino but didn't get too close. We didn't want to scare him because he might charge our minibus!

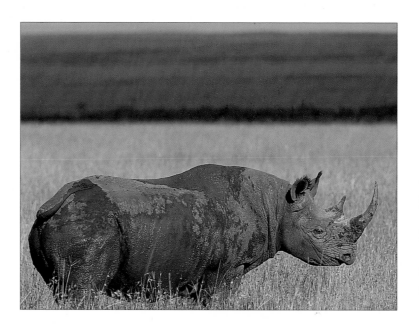

For years, rhinoceroses were hunted for their horns, which were made into such things as knife handles. Even though it is against the law to hunt them, there are now fewer than 500 rhino left in all of Kenya.

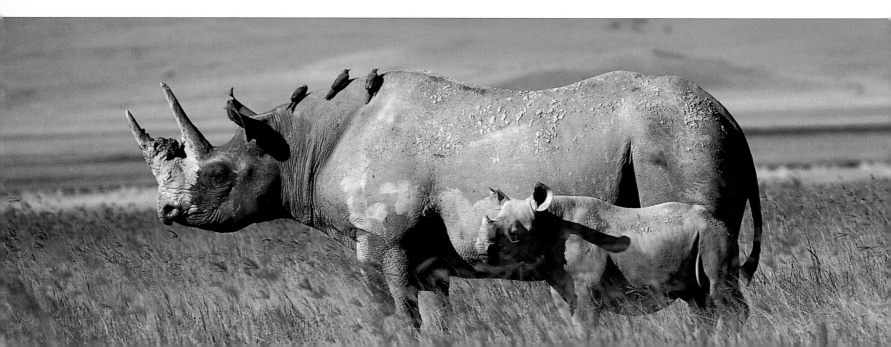

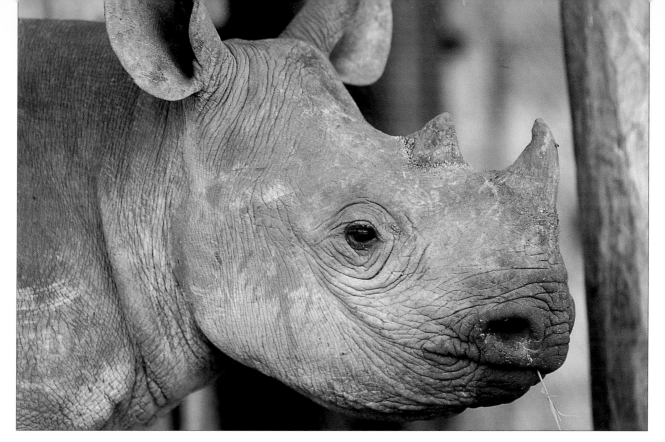

Rhinoceroses don't see very well, but they have a strong sense of smell.

There are several types of rhino in the world. They all have horns on their faces, which they can use if they have to fight. Even rhino calves have horns — cute little ones!

A full-grown rhinoceros is five feet tall and can weigh up to three thousand pounds. Wouldn't you think that such a big animal would make a loud sound? We got close enough to hear two rhino "talking" to each other. I don't know what they were saying, but the sound was a high-pitched squeal!

One evening as we were driving back to the lodge, Ahmed said, "Stop! Look in that tree!"

Everyone reached for their binoculars. The cameramen turned on their cameras.

"Wow! It's a leopard!" I said.

"And a sleepy leopard at that!" said Ahmed. "He doesn't have a care in the world. See that fat belly? He has eaten a big meal, and now he wants to rest."

At our own meal that evening, everyone talked about the animals they had seen on safari. We thanked Ahmed for being such a wonderful guide.

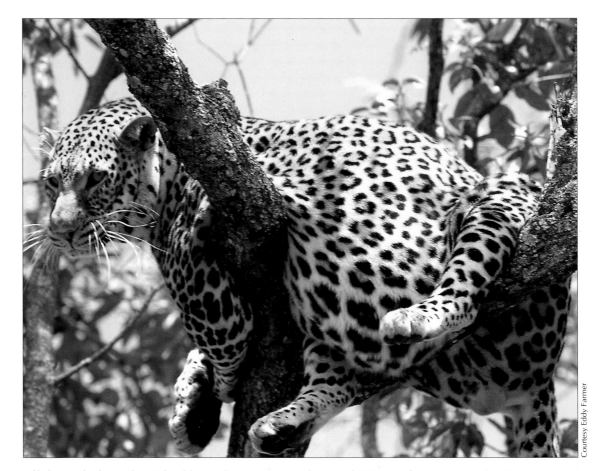

Courtesy Eddy Farmer

All through the safari, I had hoped to see a rare leopard. On our last evening in Kenya, I got my wish.

Our safari in Kenya had come to an end, but our adventure wasn't over yet. Soon we would hike the lush mountains of Uganda in search of the rare mountain gorillas.

Early the next morning, we drove back to Nairobi, boarded a plane, and flew to the Ugandan city of Kampala. We met our new guide, a young Englishman named Steve. Then we were off on our gorilla adventure!

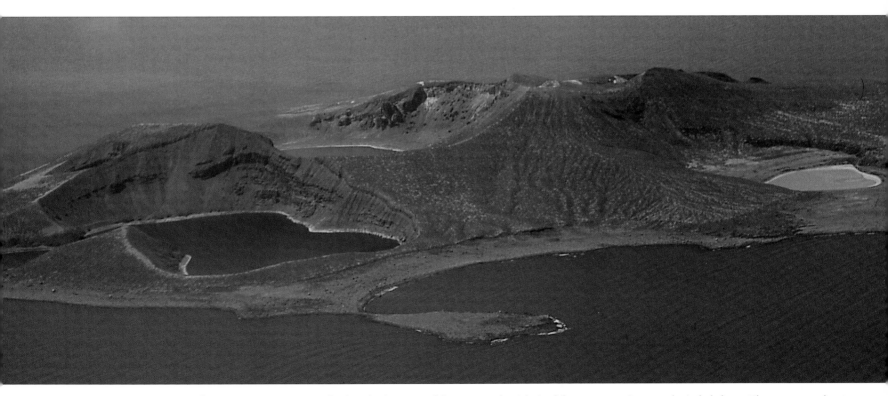

Flying over Kenya's Lake Turkana, we saw Central Island glittering like a jewel with its blue, turquoise, and pink lakes. The water takes on the colors of its microscopic plant life — called algae.

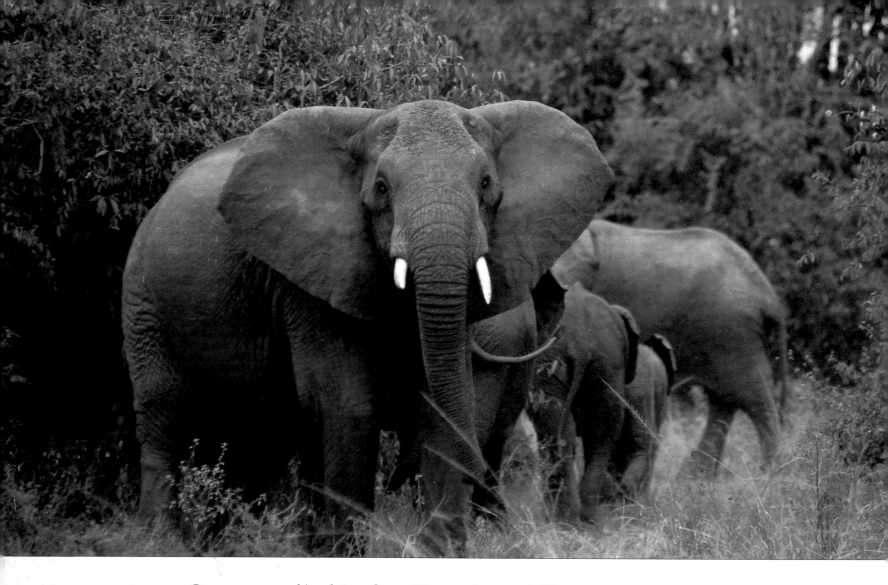

On our two-day drive from Kampala to gorilla country, we came upon an elephant herd lunching on some trees. A mother elephant was not happy to see us. She raised her head, flapped her huge ears, and rumbled loudly. Boy, was I scared! Just then, we heard a wild trumpeting sound. The ground shook!

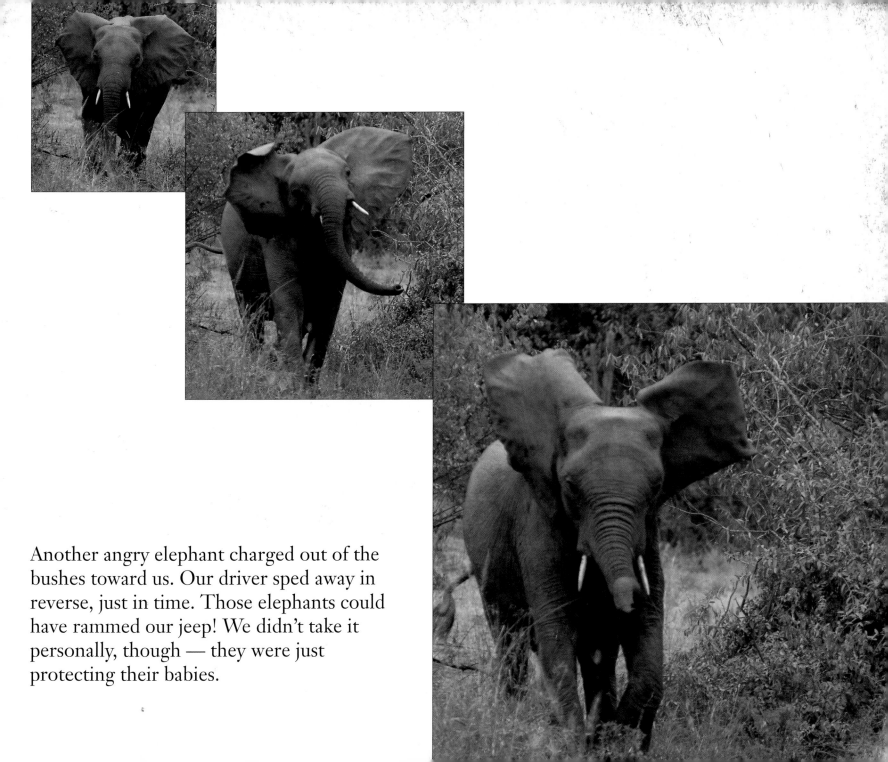

Another angry elephant charged out of the bushes toward us. Our driver sped away in reverse, just in time. Those elephants could have rammed our jeep! We didn't take it personally, though — they were just protecting their babies.

Driving away from the elephants, I wondered what adventures lay ahead in gorilla country.

Why were we so excited about seeing mountain gorillas? Like so many of the animals we had seen in Africa, they are quickly disappearing from the world. They live only in central Africa's mountain rain forests.

At a roadside market, I found a fruit that I'd never seen before. I was surprised to learn that it's called a "jackfruit!"

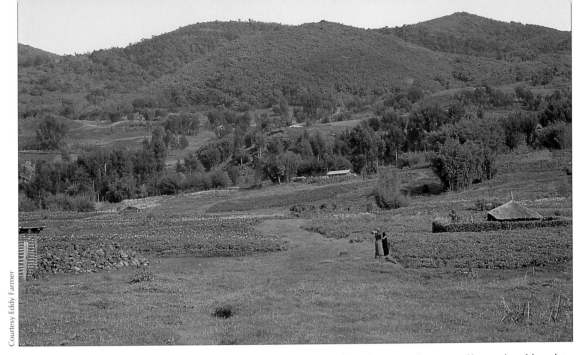

Courtesy Eddy Farmer

Finding the gorillas would be difficult. Steve introduced us to Gongo, a Ugandan man who studied gorilla habits and knew how to track gorillas. He would look for clues in the rain forest that would show him where gorillas had been and where they were headed.

One reason mountain gorillas are so rare is because they have only a small patch of land to live on. Their rain forest home is being cut down to make room for farms such as this one.

One day, my jeep got stuck in the mud — so everyone had to get out and push until we got it going again.

37

The next morning I was up before anyone else, excited about this experience of a lifetime — trekking for the endangered mountain gorillas!

As we ate breakfast, Gongo gave us the rules.

Even though we stayed in a tent camp, we were able to take showers — with a little help.

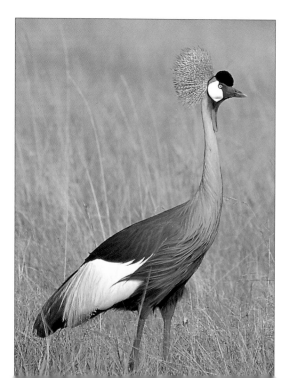

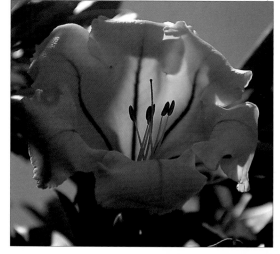

We saw many colorful flowers on our safari, such as this herald's trumpet.

The crowned crane is the national bird of Uganda.

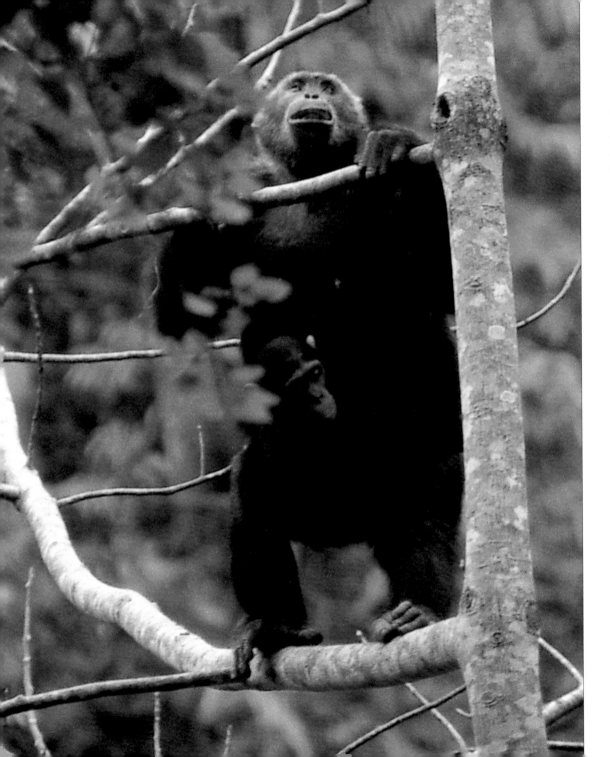

"No talking," he said. "Walk very quietly — if the gorillas know we're coming, they'll move further away and it will be a longer hike for us.

"Once we see them, don't look them in the eye — that's a threat in 'gorilla language.' Don't move suddenly, and don't go toward them. If you must cough, cover your mouth and turn away from the gorillas. They can pick up any germs we might have. And if a gorilla should charge you, don't run away — just lie down!"

Before we saw any gorillas, we came across groups of chimpanzees climbing high in the trees and hooting to each other.

39

Moving through the rain forest was slippery and slow. There were no paths. Our guides cut paths through the dense, wet undergrowth with large knives. Up, up we climbed — and sometimes crawled. I was out of breath, and we had just started!

My fatigue was forgotten when Gongo said, "Look, a gorillas' nest!" He pointed to a bed of leaves on the ground. "And up there, too!" he added, motioning to some tree branches. "A family of gorillas spent the night here, so I think we're on the right track."

During our trek in Bwindi Impenetrable National Park, I stayed close to Gongo *(foreground)* to learn as much as possible about the gorillas.

My wife, Suzi, loves animals and adventure as much as I do.

It took lots of patience to film the mountain gorillas — and a little luck.

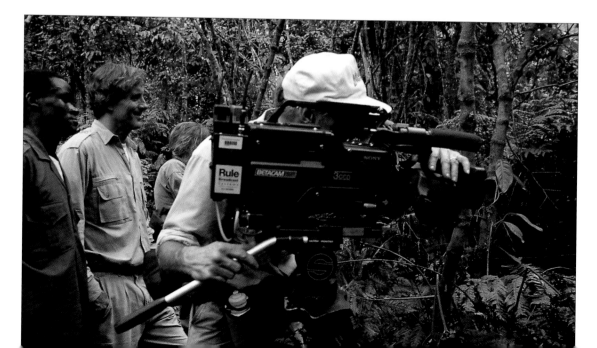

A little later, Gongo stopped again and reached toward a bush. "Look," he said. "Gorilla hair. It is the gray hair of a silverback, the leader of the group!" Wow! We were hot on their trail!

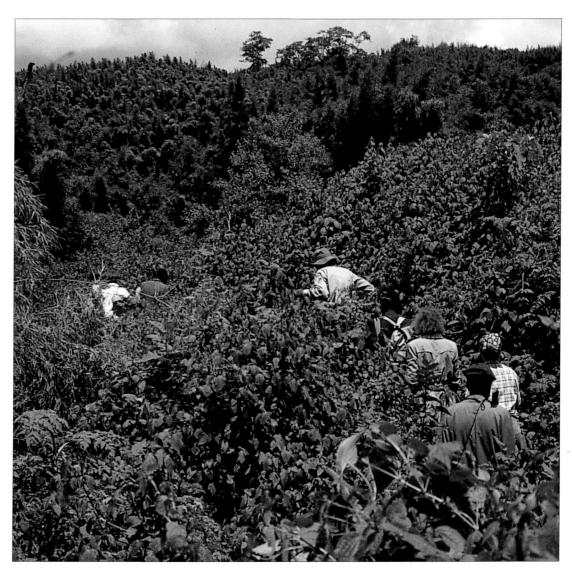

The thick vegetation made hiking difficult.

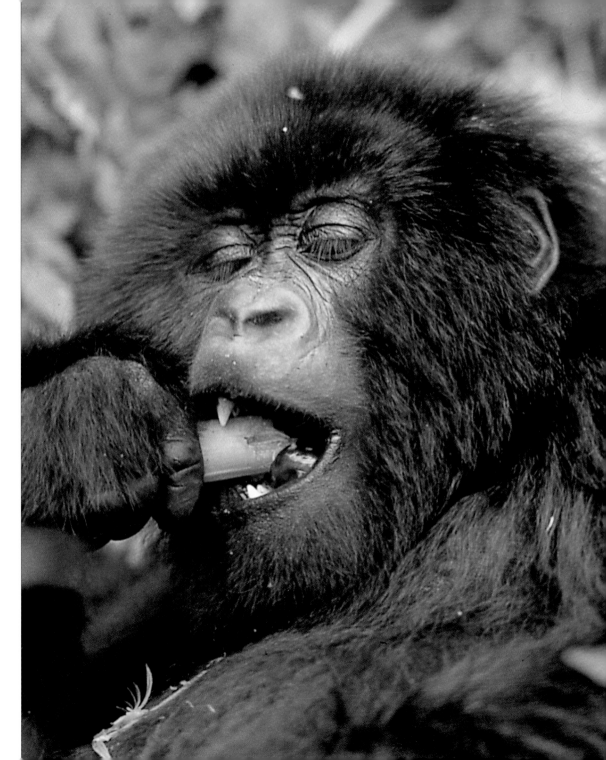

After three and a half hours of hiking, Gongo parted some foliage and pointed.

At first, all I saw was some black hair, but then a young gorilla moved into the open. He was calmly eating a piece of wild celery. Chills ran up my spine — I was experiencing something that few people ever will.

The cameramen quickly got their cameras going. We quietly watched as an even younger gorilla appeared and climbed a tree.

There are not even 500 of these magnificent creatures living today.

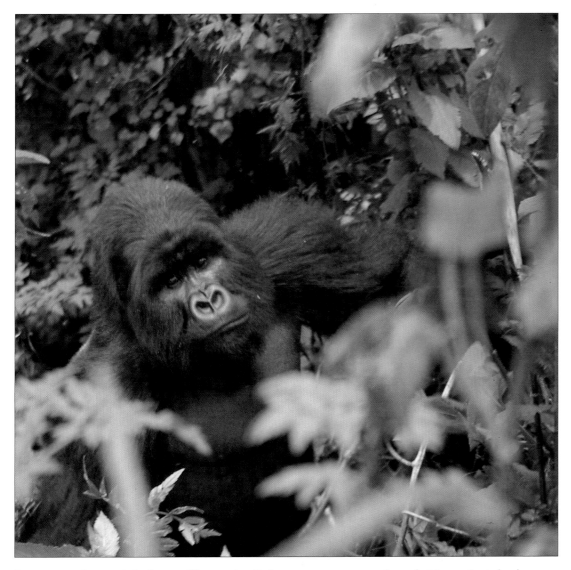

We were allowed only one hour to observe the gorillas. Our time was up all too soon. As we gathered our equipment to head down the mountain, a silverback charged us. It was startling! But I was glad to watch this magnificent animal defend his home. I hoped he would be able to live there for many years to come.

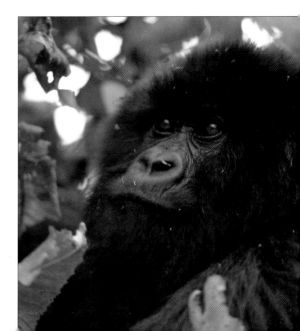

Some people catch baby gorillas and sell them as pets, even though it's against the law. You won't find mountain gorillas living in zoos, because there are too few to move from the wild.

CONCLUSION

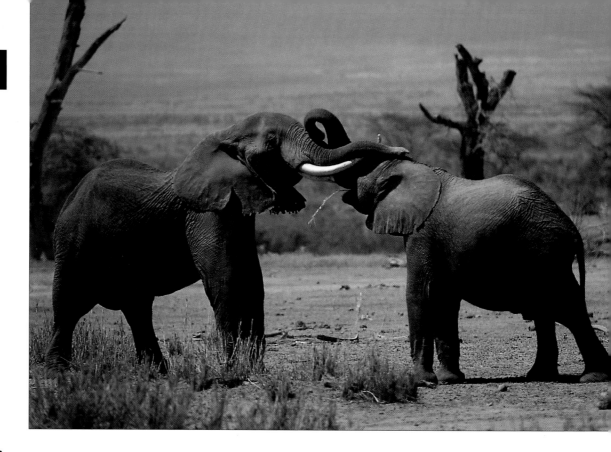

As we got ready to head back down the mountain, I realized that our safari was over. While everyone was a little sad to see it end, we couldn't wait to tell our families and friends about our adventures.

Many of the animals you have seen in this book are endangered. But there is hope for the mountain gorillas — and the elephants, rhinoceroses, and leopards too. All over the world, many people are working to save them. They set aside land for the national parks where the animals live. They pass laws against poaching, which is the illegal hunting of animals.

As a zoo director, I've had many chances to help animals. Sometimes we are able to raise an animal in the zoo and then take it back into the wild to find a mate and raise a family there. More often I talk to people about the importance of saving animals all over the world.

Everyone on our safari decided that, from then on, they would do anything they could to help the animals, too!

ABOUT THE AUTHOR

ack Hanna is Director Emeritus of the Columbus Zoo and a noted wildlife conservationist. He is the author of several books about wildlife, and is well-known for sharing his enthusiasm about animals on such television shows as *Good Morning America*, *The Late Show with David Letterman*, and many others. As host of the syndicated television series *Jack Hanna's Animal Adventures*, "Jungle Jack" has traveled to some of the most remote parts of the world in search of wildlife, and says that nothing compares to the adventure of an African safari.